WINSLOW HOMER IN THE 1880s

WATERCOLORS, DRAWINGS, AND ETCHINGS

DECEMBER 9, 1983 - JANUARY 29, 1984

EVERSON MUSEUM OF ART · SYRACUSE, NEW YORK

Everson Museum of Art is supported by
the National Endowment for the Arts,
the New York State Council on the Arts,
Onondaga County, the City of Syracuse,
membership, independent contributions, and endowments.

ISBN: 0-914407-01-5

Cover Illustration: *A Good One, Adirondacks,* 1889
Design Consultant: C.W. Pike
Printing: Salina Press
Published by: Everson Museum of Art, Syracuse, NY, 1983

Preface

For more than a century Winslow Homer has been among the best-known of American artists. Everson Museum of Art is fortunate to be able to bring together a remarkably rich selection of Homer's work from a single decade, the 1880s. This was a decade in which the artist traveled more widely than ever before, from the North Sea to the Caribbean and from the Adirondacks to the coast of Maine. The Everson's own important Homer drawing, *The Smuggler of Prout's Neck*, is an early record of the life he began on the rocky shore of New England in the 1880s. This was also the decade of Homer's etchings. They are exhibited here in one of their rare showings as a complete group.

The Everson is fortunate to have Professor David Tatham of the Department of Fine Arts of Syracuse University, one of the nation's leading Homer scholars, serve as guest curator of the exhibition. He has selected the works and written the catalog. This is an exemplary instance of the fine cooperation possible between a distinguished Syracuse University scholar and the Everson.

We also wish to express our appreciation for the support of this exhibition by the National Endowment for the Arts, and to Fay's Drugs and its Chairman, Henry A. Panasci, Jr., one of our dedicated Museum Trustees. They have helped us realize this new study and unique exhibition of the works of one of the most universally admired artists of the United States.

Ronald A. Kuchta, Director
Everson Museum of Art

3

Pl. 1
Old Drover's Inn, Prout's Neck, 1887
Berry-Hill Galleries

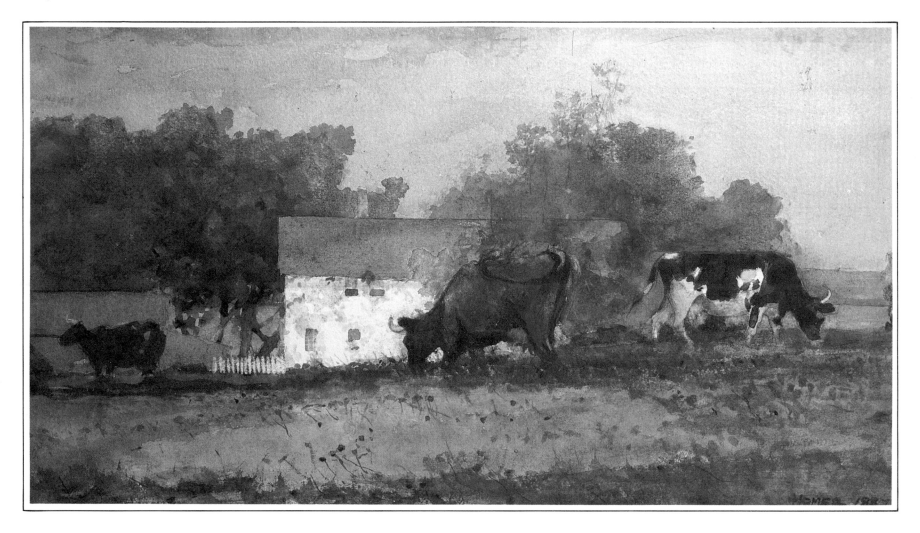

Winslow Homer in the 1880s

"He paints his own thoughts, not other people's," wrote the critic George Sheldon of Winslow Homer in 1878.[1] In saying this, Sheldon was attempting to explain why Homer's new work so often surprised his contemporaries and why, despite the sometimes unexpected directions it took in subject and style, it remained all of a piece. As a painter Homer continued to surprise his viewers for the rest of his career, and never more so than in the 1880s. He did this not through any conscious attempt at novelty but rather through the singular course of his artistic development.

Homer's development was remarkable for both long duration and unexpected directions. In duration it lasted for fully half a century, beginning in the late 1850s and ending only with the collapse of his health a year or so before his death in 1910. In its directions his development was sustained and controlled by ceaseless introspection concerning the aims and means of naturalistic representation. It was a development that can be seen as a logical progression of problems set and solved as well as a response to the experience of places and events. Certainly it demonstrated the steady growth of a visual intellect that was already impressive in 1862 when Homer began painting in earnest. His progress was largely independent of the influence of others and of the fashions of the art market. While the work of many of his fellow painters in the last third of the nineteenth century can be explained well enough in terms of such period styles as Impressionism, Luminism, and Tonalism, Homer's cannot. In observing that Homer painted his own thoughts, and not others', Sheldon might have added that Homer's thoughts did not lend themselves to successful imitation. He followed no one and had no important followers.

The most dramatic advances in Homer's development occurred in the decade of the 1880s. They can be seen even more clearly in his work on paper — watercolors, drawings, and etchings — than in the oils he completed in this decade. Homer's oils of the 1880s, fine as they are, represent the early and middle stages of a phase of his work in that medium that culminated in the 1890s. But in his smaller works on paper (some of which are closely related to his oils) he addressed a different range of problems. He became adventurously innovative in watercolor, constantly probing to find new responses to the challenges he set for himself. His new insights informed his oils, but he quite rightly never thought of his drawings and watercolors merely as exercises or preparatory studies. He exhibited and sold them as separate works. In the 1880s he realized more from the sale of many dozens of them than he did from the few oils that found owners in that decade.

The works selected for the exhibition *Winslow Homer in the 1880s*, most of which are little known to the public, document the arrival of unexpected new strengths in Homer's work as the decade progressed. As a group they go far to explain the creative mind of one of the major figures of American art.

Gloucester and Cullercoats

In February, 1880 Homer turned forty-four.[2] His career as an illustrator was behind him and he was now firmly established as one of the foremost artists of his generation in America. His reputation was primarily that of a painter of figures; he typically set them in the rural outdoors. A certain naiveté resulting from his lack of academic training persisted in his work through the 1870s. It has always been viewed as more of a strength than a weakness, an instinctive honesty of expression with its own untutored eloquence. It seemed to suit both the man and his subjects. He was a remarkably able and highly distinctive draughtsman. His decorative sense unified rather than prettified his work. His powers of pictorial composition were unexcelled in America.

In the late 1870s Homer had shown all of these skills to good advantage in an extensive and important series of watercolors and drawings of young women and children that surpassed all of his earlier treatments of these subjects.[3] Quietly lyrical in mood, virtually without anecdote, small in scale, linear in style, carefully composed, and much concerned with how bright outdoor light clarifies forms, they gained him the warmest critical praise he had yet received. Because he explored these subjects so thoroughly, some critics assumed that he had found his metier. But he spend much of the summer of 1880 exploring quite a different subject in quite a different way, confounding those who had expected him to remain the painter *par excellence* of shepherdesses and bucolic children.

In July and August 1880 Homer spent some weeks on Ten Pound Island in Gloucester Harbor on Cape Ann, north of Boston. There he examined in watercolor the ways in which light and moisture-laden air transform the appearances of the visible world.[4] Suddenly gone from his work were sharp-edged shadows, brilliant highlights, and decorative touches. In most of these watercolors the human figure is absent. When it is present its details dissolve in an all-encompassing light. The conditions of light he sought were no longer those of bright, clear days, sharp in definition, but rather the more generalized light of haze, mist, fog, and sunset that robs objects of their local color. He had known such conditions all his life, of course, including in Gloucester when he had painted there in the summer of 1873, but only now did he make them his chief interest. His watercolor technique became looser and his colors more expressive of the complexity of diffused light. He made a large number of rapidly executed watercolor sketches that record the appearances of a moment (*Two Girls in a Rowboat,* Fig. 1) and examine the effects of special conditions of light (*Sunset Fires,* Fig. 2). He also produced a smaller number of more thoroughly composed and highly finished works — probably completed in his New York studio — in which the architectural forms of ships and harborside buildings impose a greater sense of calculated design.[5] But even in these it is the quality and color of the light that first arrests the attention.

Homer's new way of painting light was not limited to Gloucester Harbor subjects. There are intimations of it in works painted elsewhere in 1879 and 1880. His *Young Woman* of 1880 (Fig. 3) is such a transitional work.[6] Painted perhaps at Greenwich, Connecticut in the spring of the year, it is among the last of his treatments of fashionably dressed young women, a subject that had occupied him from time to time since the mid-1860s.

In the spring of 1881, following the successful exhibition of a large group of his 1880 watercolors in Boston, and a mixed reaction to a smaller group in New York (where his viewers had expected more shepherdesses), Homer sailed for England. His reasons for choosing to visit England are not known, though the ways in which his work benefitted from his stay are clear. He was in England for about a year and a half, returning to New York in November 1882.[7] He worked intensively, mostly in and near the North Sea fishing village of Cullercoats, not far from Tynemouth in the north of England. He probably painted his well-known *Houses of Parliament* in London before traveling to the north, since it epitomizes what he had aimed for in his work of 1880 in Gloucester and shows no sign of the developments that took place in Cullercoats.[8]

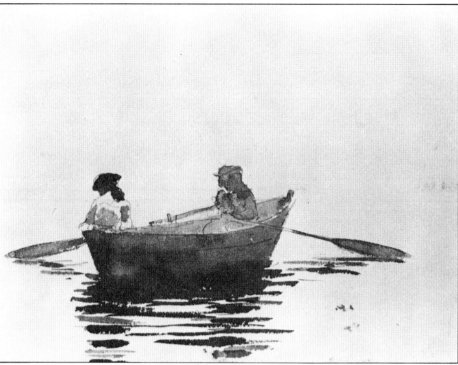

Fig.1 *Two Girls in a Rowboat,* 1880, Cooper-Hewitt Museum

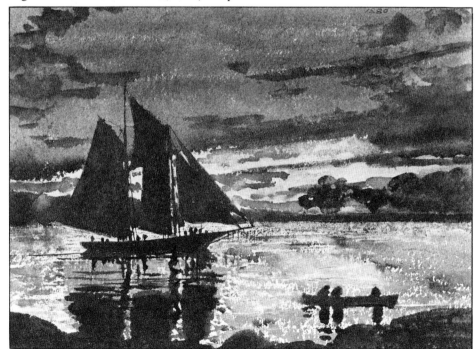

Fig.2 *Sunset Fires,* 1880, Westmoreland County Museum of Art

Pl. 2
Forebodings, 1881
Hyde Collection

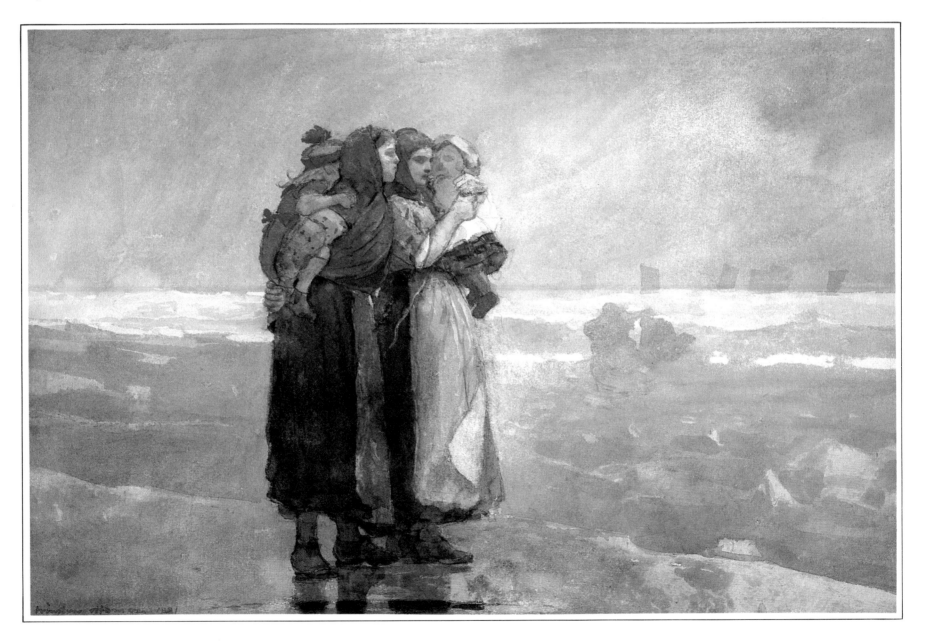

The life Homer chose to paint in England was the hardy and dangerous life of the fisherfolk. He could have chosen other subjects — fashionable watering spots were nearby — but he did not. After the lapse of a year his primary interest was again the female human figure, but his treatment of it was profoundly changed. His figures took on a new solidity. He incorporated them into their settings with greater skill and he made those settings more complex and active than he ever had before. The figures have a psychological dynamism previously unseen in his work. These women watch the sea intently and sometimes anxiously. In moments of repose they seem to contemplate graver matters than did Homer's day-dreaming shepherdesses.

There was an intrinsic drama to lives spent in a fishing village at the edge of a stormy sea. Homer heightened it in composing his pictures. He silhouetted women against sea, sky, and cliffs (*A Voice from the Cliffs,* Fig. 4), grouped them together as if for safety against a hostile environment (*Forebodings,* Pl. 2), and set them in the still center of a boisterous fisherman's beach (*Fisher Girls on the Beach, Tynemouth,* Fig. 5). He emphasized the pictorial qualities of their dress, using the flowing lines of shawls, kerchiefs, skirts, and aprons as important elements of design as well as objects of interest in their own right. These are less delicate figures than Homer had painted in the 1870s — they are womanly rather than girlish — but they are, in their different ways, fully as feminine.

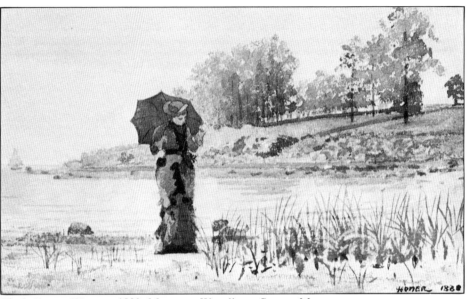

Fig.3 *Young Woman,* 1880, Margaret Woodbury Strong Museum

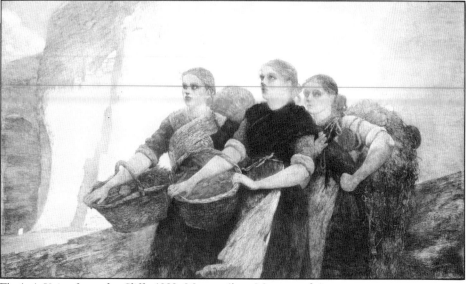

Fig.4 *A Voice from the Cliffs,* 1888, Metropolitan Museum of Art

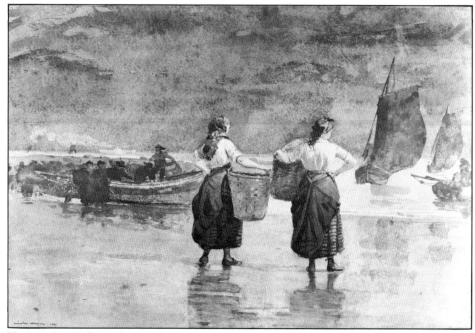

Fig.5 *Fisher Girls on the Beach, Tynemouth,* 1881, Brooklyn Museum

He sought and achieved a monumentality in his English figures of a kind that he had rarely attempted before. There can be little doubt that he comprehensively rethought his approach to drawing and painting the human figure during his stay in England. He became more adept at portraying the volume and weight of bodies. He even undertook the daunting task of depicting monumental figures in motion. His *Incoming Tide* (Fig. 6), completed in New York in 1883, is an imposing example. Striding towards the viewer, dramatically set against a breaking wave, this figure represents the culmination of another phase in Homer's rigorous retraining of himself.

In England Homer increased his mastery not only of the human figure but also of nearly everything else. His art took on a new seriousness of outlook, and he aspired to more. It is hard to say what in his experience in England contributed most significantly to his great gain in creative power, or whether the gain might have come about even if he had never gone to England. But it would be a mistake to think that this development resulted simply from his exposure to new surroundings. The evidence of his work is that he was exploring a number of directions relating to means of expression, and that he was determined to work each of them through on his own, intuitively. He did this chiefly in two locations — Ten Pound Island and Cullercoats — where those who knew his work of the 1870s would not be looking over his shoulder. If he was in fact consciously attempting to remake himself as an artist, he must have had some sense of satisfaction with the outcome. In the span of about two years he had transformed himself from an exceptionally able artist to a powerfully original one, and from an artist whose work was essentially lyrical in character to one who seemed on the threshold of something deeper and more profound.

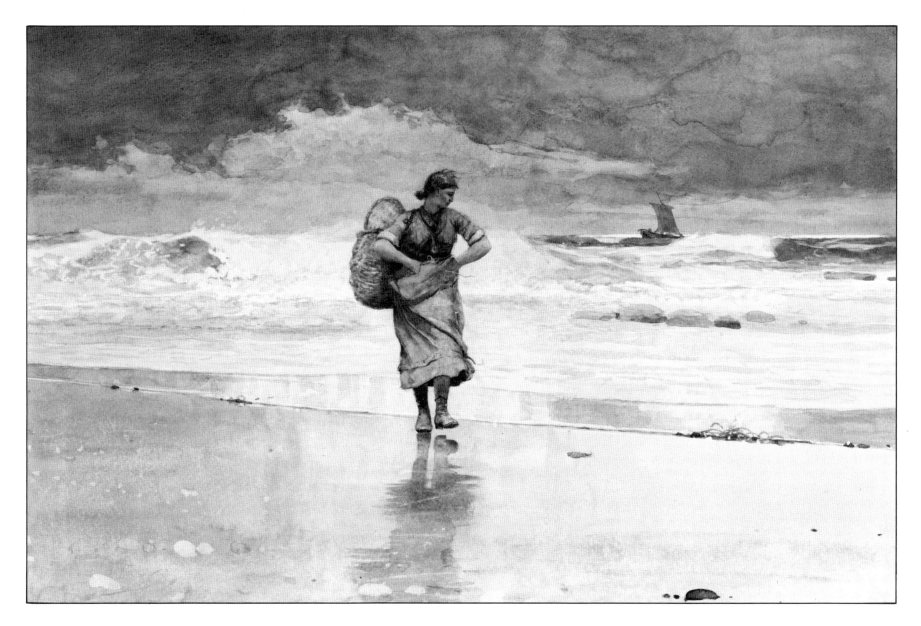

Maine, the Caribbean, and the Adirondacks

Fig.7 *The Northeaster,* 1883, Brooklyn Museum

After spending the winter of 1883 in New York, where he had maintained his bachelor quarters and studio since 1860, Homer moved to Prout's Neck, a few miles south of Portland on the Maine coast. He had known this sparsely populated, rocky promontory since the mid-1870s when his brothers and parents began summering there. He moved the stable of the family's summer home to a location overlooking the open sea and converted it into a studio-residence. This remained his home for the rest of his life. His reasons for quitting New York have never been satisfactorily explained, though one factor was surely that no one there was any longer capable of contributing to his development, while everyone posed a distraction. The relative isolation of Cullercoats had been a wholly positive influence; Prout's Neck offered similar conditions. The notion that he lived a hermit-like existence in Maine is entirely mistaken. He established abiding friendships with local fishermen and farmers and their families, traveled extensively, and was surrounded by his relatives each summer. It is true that he turned his back to the New York art world and to what the public expected of eminent artists. He refused to hold court, to cultivate a popular image, to serve organizations, or to rest on his laurels. He became increasingly brusque with journalists, tourists, and other strangers who searched him out. His great preoccupation remained his work.

During his first years at Prout's Neck that work was unusually varied. He embarked on a sequence of oil paintings on dramatic subjects related to the sea, stronger than anything he had done in England.[9] He made several major etchings (discussed below) based on these oils and his Cullercoats works. Scrutinizing his new surroundings, he made a number of closely observed, highly objective drawings and watercolors of ledges and scrub. In watercolors such as *Northeaster* (Fig. 7), he began to make the dynamic power of the sea his main subject. In 1884 he depicted the working life of Maine fishermen and others who lived close to the sea in a series of drawings. His *Fisherman on Shore* and *Smuggler of Prout's Neck* (Fig. 8) are two of these. If the provocative title of the latter is original with Homer, it may be a wry reference to the delivery of a cask of spirits to Homer's studio out of sight of his abstemious father. Then, in the winter of 1884-1885, he made the first of his visits to the Caribbean.

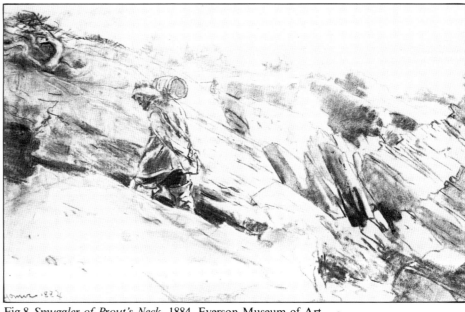

Fig.8 *Smuggler of Prout's Neck,* 1884, Everson Museum of Art

He went to Cuba and the Bahamas. It is clear from his watercolors that he was astonished, as every first-time visitor is, by the color, light, and life of the tropics. These watercolors are more economical in technique and less obviously composed than his English work in the medium. They have a greater sense of immediacy, as if Homer, fired by what he saw, recorded it rapidly and vigorously, and then left it. In fact, most of these watercolors received final touches of one kind or another in his studio. *Santiago de Cuba* (Pl. 3), is one of his rare panoramic views; it may have been inspired by the pictorial strength of the serrated ridgeline of the great Sierra Maestra massif. His *View of Street, Santiago de Cuba,* captures both a tourist's fascination with an exotic environment and Homer's attempt to show how the shimmering midday light of hot places drains away local color. In other watercolors, such as *At Tampa,* (Pl. 4) one of a stunning group resulting from his trip to Florida in the winter of 1885-1886, he reveled in the brilliance of tropical color. The studied, often sculptural quality of his English figures was replaced by more naturalistic, spontaneously recorded ones, most of them black men and women.

After returning from Florida early in 1886, Homer painted very few watercolors until the summer of 1889 when he began his long Adirondack series. His attention in the intervening years was largely on his etchings. But two watercolors of 1887 make it clear that everything he had learned about the medium had now been consolidated into the mature style that made him the supreme American master of watercolor. Both works show that he was still exploring Prout's Neck, but now, briefly, its interior rather than its rock-bound seafront.

In *Woods at Prout's Neck* (Fig. 9), two well-dressed young women — very likely guests or neighbors of the Homer family — are seen at the edge of an overgrown field in autumn. This is a rare reappearance of such figures in Homer's work. Unlike their predecessors of the 1870s, they are subsidiary elements in a work chiefly concerned with the forms and colors of foliage. Homer created the foliage with an extraordinary variety of brush strokes, each unique in size and shape and each a vivid record of the energy that made it. None are tenative; none superfluous.

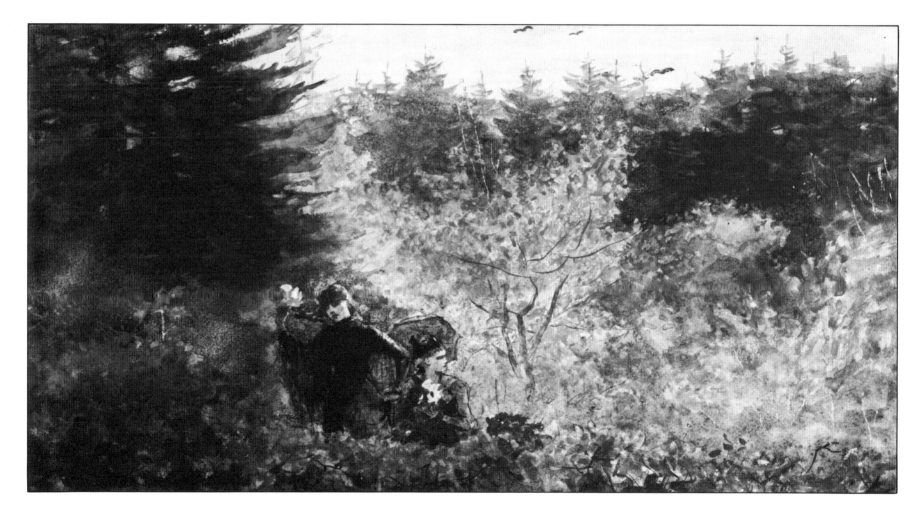

Fig. 9
Woods at Prout's Neck, 1887
Kennedy Galleries

Fig. 10
Jumping Trout, 1889
Brooklyn Museum

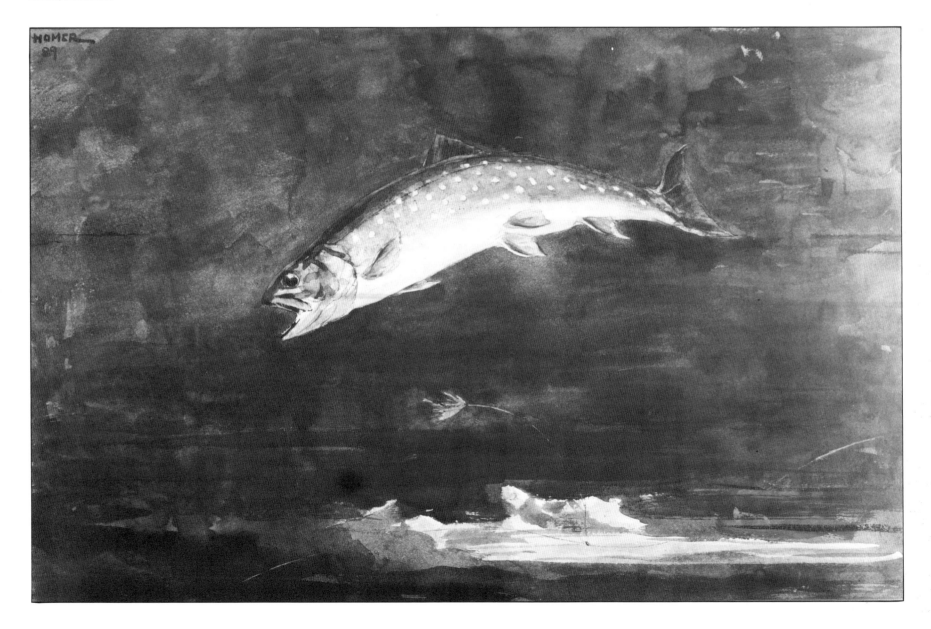

Old Drover's Inn, Prout's Neck (Pl. 1) takes its title from the old (1706) building depicted at center, once an inn but in Homer's time a summer residence. Though the subject echoes his pastoral interests of the 1870s, the style is distinctly that of the late 1880s. Everything he had learned about watercolor earlier in the decade informs this work in subtle ways. It is seen in the unifying light, the secure naturalism of the cows, the richness of the color — he would never have made Saco Bay so blue before seeing in the Caribbean how blue water can be — and above all in his technique, simultaneously free and controlled in a way that was completely his own.

This mastery became bolder still in the Adirondack watercolors that he began to paint in 1889 and continued for many years. He made these during his visits to the North Woods Club on Mink Pond deep in the forest west of Minerva, not far from the turbulent upper Hudson. He went there primarily to fish. *A Good One, Adirondacks* (cover illustration) is among the finest of his many paintings of a sport he knew well. In such works as *Jumping Trout* (Fig. 10), his remarkable knowledge of the appearance and behavior of game fish make his depictions of them among the most convincing in existence. Part of his success comes from placing the viewer in the position of a companion fish, offering an intimacy of association with wild life that is beyond the experience of most people. He also recorded the rugged life of guides and loggers (*The Hudson River — Logging,* Fig. 11). His brushwork became even more assertive, as it also did in his oils in these years.

The deep surround of wild nature — forest, mountains, lake, river — in Homer's Adirondack works is as alive with dynamic energy as is the ocean in his mature paintings of the sea. The natural world that he began to paint in the 1880s contains nothing that is static, nor anything that is essentially symbolic or aesthetic. He shows nature to be an active force, vibrant with life, constantly in flux. This was a portrayal that was fully in harmony with the emerging concepts in western thought that found every living thing — each human being, above all — to be a discrete source of vital energy.

Fig. 11
The Hudson River -- Logging, 1889
Corcoran Gallery of Art

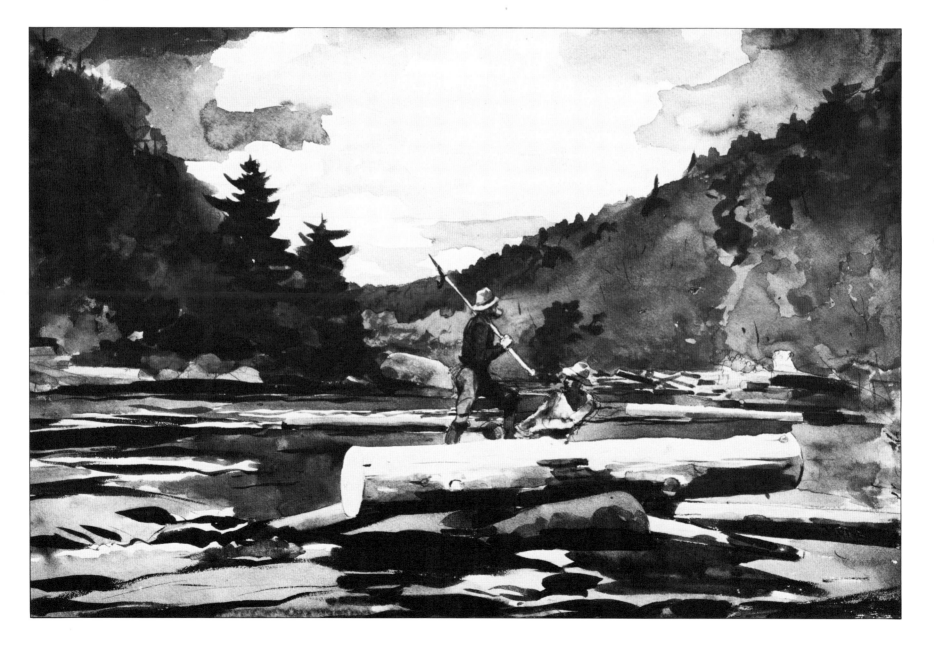

Homer's Etchings

The kinetic energy seen in Homer's watercolors and oils of the late 1880s is also found in his etchings.[10] It distinguishes them from most other American fine prints of the period and helps to explain why they were not better received. He looked to fellow artists and his printer, George Ritchie, for advice on technical matters but, characteristically, he went his own way in subject and style.

The extent of the interest of American painters of the 1870s and 1880s in etching as a medium of expression is difficult to imagine a century later. It was encouraged by the revival of etching as fine art in Europe, by the example of Whistler in England, by the persistent advocacy of American etching by such art editors and critics as S.R. Koehler, and by the rapid growth of print clubs and print collections. The taste of the times called for original subjects that were rapidly and sensitively executed in small format, and refined in feeling. By and large, Homer ignored this taste in his own work as an etcher.

His earliest known etching, *Young Girl in a Chair*, is close in subject and style to his drawings of the late 1870s. It is clearly a trial plate by a novice etcher; much of the line is tentative and awkward. The difference between it and the strong, confident line of his first published etching, *The Life Line* of 1884 (Fig. 12), is little short of miraculous. The latter print is adapted from the dramatic oil of the same title that was greeted with high praise and immediate purchase when it went on show earlier in the year. Unlike reproductive prints of the kind that professional printmakers made after the paintings of others, Homer's etching represents a thorough rethinking of his picture. He eliminated certain details and reduced its horizontal emphasis. The forcefulness of his line matches the high drama of the subject. One of his last etchings, *Saved* of 1889, is a further rethinking of the subject, with the image reversed.

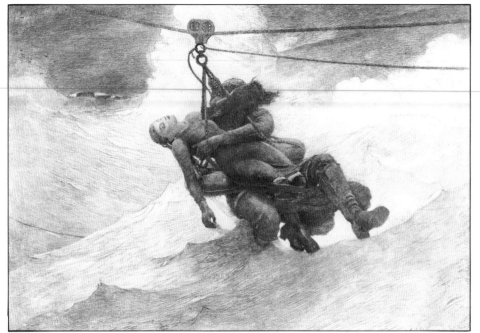

Fig.12 *The Life Line*, 1884, Margaret Woodbury Strong Museum

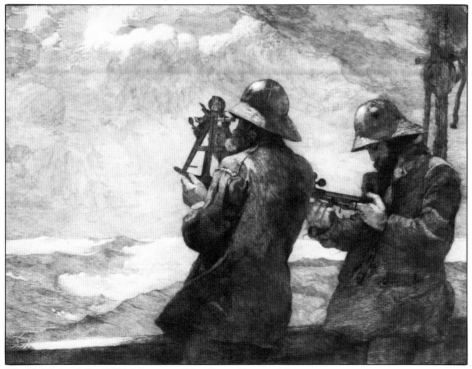

Fig.13 *Eight Bells*, 1887, Margaret Woodbury Strong Museum

He assayed the possibilities of an etching adapted from his oil of 1886, *Undertow*, but the result, admirable in many ways, has a number or unresolved problems chiefly related to the figures of the two women who, locked together, struggle against the sea. Without the figures of the lifeguards who support them in the painting, both the predicament and the appearance of the women are not wholly convincing. On the other hand, his etching *Eight Bells* (Fig. 13), made from his oil of the previous year, is a complete success. In 1888 he looked back to some of his English watercolors for subjects and etched *the Perils of the Sea, A Voice from the Cliffs* (Fig 4), and *Mending the Tears* (Fig. 14). Homer originally titled the last of these *Improve the Present Hour,* a title that remains lettered, perhaps in his hand, on the late state of the etching deposited for copyright at the Library of Congress in 1888.

Of these, *A Voice from the Cliffs* has the most complex history. The image of three women standing closely together, carrying baskets and fishnets, first appeared in Homer's oil *Hark! The Lark* of 1882, a painting that takes its title from the song in Shakespeare's *Cymbeline*, popular in more than one musical setting in the nineteenth century. He exhibited it at the Royal Academy in 1882. Later in the year, or early in 1883, Homer made a large watercolor of this group, *A Voice from the Cliffs*, in which he reduced the figures from full-length to three-quarter. In the oil the figures stand on high ground; in the watercolor they are on a beach with the chalk cliffs of Flamborough Head rising up in the background. The titles of both works encourage the viewer to think that the uplifted eyes of the women are in response to a sound from above.

A sketch of these figures, probably by Frederick S. Church, was reproduced on the cover of the catalogue of the annual exhibition of the American Watercolor Society in 1883. A small reproduction of the watercolor, engraved in wood by Timothy Cole, illustrated Mrs. Schuyler Van Rensselaer's important article on Homer in the November 1883 number of *Century* magazine. In 1886, with Homer's blessing, James D. Smillie made a skillful reproductive etching of the watercolor for use as a plate in S.R. Koehler's *American Art*, published in 1886. Homer went so far as to critique a proof[11]. Then, in 1888, he made his own etching, reversing the image and making numerous significant changes in his design. He returned to one woman's back a basket seen in his oil but absent from his watercolor. The setting is markedly different; the strong diagonal of a massive rock now separates the group from the beach, the water, and the distant cliffs, all of which are thoroughly restudied. The edition apparently consisted of only a few impressions — six are recorded — but Homer's new publisher, C. Klackner, also issued a photogravure of the etching, impressions of which Homer signed as though they were artist's proofs. In 1889 the French etcher Pierre Teyssonnieres brought forth his own version, the image of the figures reversed as in Homer's etching but the background taken from the original watercolor, perhaps through Smillie's version of it.

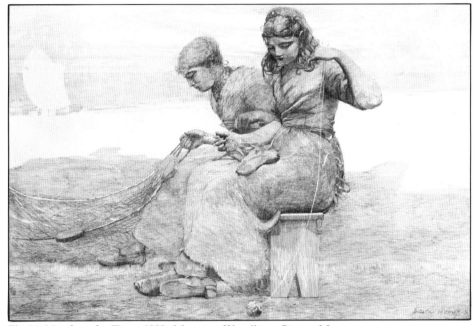

Fig.14 *Mending the Tears,* 1888, Margaret Woodbury Strong Museum

22

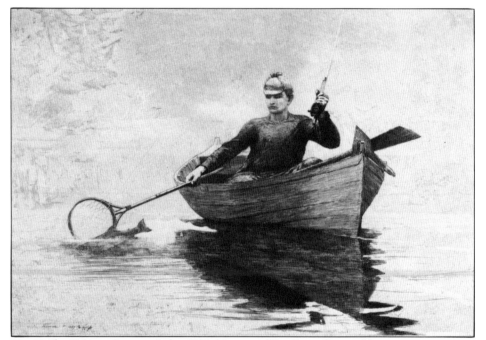

Fig. 15 *Fly Fishing, Saranac Lake,* 1889, Margaret Woodbury Strong Museum

Homer's last etching, *Fly Fishing, Saranac Lake* (Fig. 15), made late in 1889 after he returned from the Adirondacks, is his only wholly original design and his only etching published in a numbered edition. It consisted, apparently, of 100 impressions. For the first time he made use of aquatint, creating a background suggestive of the vibrant foliage seen in his watercolors. The moustachioed fisherman, in a fore-and-aft cap, netting his catch from an Adirondack guide boat, is one of Homer's finest male figures.

Homer doubtlessly assumed that the critical success of his oils and the encouraging sales of his watercolors would create a brisk "artist's proof" market for his sensitive reworkings of some of his most widely admired pictures. He was wrong. His etchings were too expensive for the mass market for art reproductions and too seemingly unoriginal, large in format, and strong in conception and execution for collectors of fine etchings. His arrangements for making them had never been ideal — he bit the plates at Prout's Neck and then crated and shipped them to his printer in New York, who mailed proofs back to him. When it became clear that their sluggish sales would not repay the time he spent on them, Homer abandoned work as an etcher. Not until well into the second half of the twentieth century did it become clear that these prints constitute a major achievement in the history of the graphic arts in America.

The Master at Home

By 1889 Homer was settled into his life at Prout's Neck and had good reason to be pleased with what he had accomplished in matters of art during the decade. No doubt he was. Yet he also harbored persistent resentments about how his art had been received. These, directly and indirectly, increasingly colored his relations with others and gradually contributed to his reputation as a misanthrope. He resented the slowness of most American critics and collectors to appreciate his strengths. Even more he resented the slow sale of his oils and the modest prices they realized compared with those of such painters of high fashion as John Singer Sargent. Far from being alienated by the materialism of late nineteenth century American culture, Homer subscribed wholeheartedly to its tenet that money is the ultimate measure of success. In these terms he found himself always underpaid, and it rankled him.

His resentments probably rested on a deeper foundation of personal hurt and insecurity, as persisting grievances often do, but it is difficult to say precisely and confidently what its nature may have been. His reserved, taciturn, and business-like manner — the protective devices of an essentially shy person — hid most of his feelings from his contemporaries and left little for later biographers to work from. Certainly none of the recent attempts at an emotional analysis of the man have been persuasive. There is, in any event, no very good reason to believe that he was a profoundly unhappy person. To the contrary, his withdrawal to Prout's Neck seems to have been a successful adaptation. His often repeated assertion that he had found genuine contentment living at the edge of the sea — he was in fact truly alone there only for those weeks of the winter when he was not in the Caribbean — was probably true. The evidence of his work supports it.

The creation of this work became the great motivating force of his life. The isolation required for its making cost him much in the way of social and domestic rewards, and he doubtlessly resented this too, but it gained him the solitude necessary for the considerable mental effort that underlies his work. Like all great realist artists he did far more than transcribe the appearances of what he saw — his comment to the contrary notwithstanding[12] — and he did this best apart from the world of art. How well he had come to understand the multitudes of truth that exist in any moment of reality, and in any masterpiece of fine art, began to be clear in the 1880s and has become clearer still in the century since.

What Homer learned in the 1880s about art, nature, and himself led directly to his great oils and watercolors of the 1890s. These swept aside any lingering reservations about his true stature as an American master. He took little notice of the chorus of praise that now grew year by year however, and instead settled ever more deeply into the life that he had begun at Prout's Neck in the 1880s — painting, gardening, and contemplating the sea.

David Tatham
Syracuse University

Notes

I am grateful to Betsy Turck and Carol Damico, graduate students in the Department of Fine Arts of Syracuse University, for invaluable research assistance throughout the planning of this exhibition; to Margaret Baird and Michael Justice, graduate students in my Homer/Eakins seminar in the fall of 1983 for much resourceful help; and to Colleen Adour, Rita Alexandrides and Beth Strum, and Malcolm O'Malley of Everson Museum of Art for making the practical problems of bringing the exhibition from concept to reality seem easy. Above all, I am grateful to the lenders to the exhibition whose generosity of spirit has made it possible to assemble such a choice group of Homer's works.

1. George Sheldon, "American Painters — Winslow Homer and F.A. Bridgman," *Art Journal* 4 (August 1878): 227.

2. The best biography remians Lloyd Goodrich, *Winslow Homer* (New York, 1944). Some additional biographical details can be found in Gordon Hendricks, *Life and Work of Winslow Homer* (New York, 1979), valuable also for a large number of reproductions of Homer's work.

3. A number of these are reproduced and briefly discussed in David Tatham, *Winslow Homer Drawings 1875-1885*, exhibition catalogue (Syracuse, 1979).

4. Homer's "isolation" on Ten Pound Island has perhaps been overstressed in discussions of the artist. His isolation consisted of taking room and board with the family of the island's lighthouse keeper. He had easy access to the town by boat. The island location enabled him to observe the effects of light on and over water around the clock without distraction.

5. For example, his *Gloucester Schooners and Sloop*, 1880, reproduced in Hendricks, *Homer*, p. 121.

6. The final digit of the date is obscure but both the woman's costume and Homer's style argue convincingly for 1880.

7. A detailed study of Homer's stay in England is currently in preparation by A.J. Harrison of Cullercoats.

8. Reproduced in Hendricks, *Homer*, p. 147.

9. Among them are *The Life Line* (1884), *The Fog Warning* (1885), *Eight Bells* (1886), and *Undertow* (1886).

10. For the fullest account of the etchings, see Lloyd Goodrich, *The Graphic Art of Winslow Homer* (New York, 1968), pp. 13-19.

11. Homer to S.R. Koehler, June 30, 1886. Private Collection.

12. In answer to a question about whether he ever modified the color of things he painted from nature, Homer is reported to have replied, "Never! Never! When I have selected the thing carefully, I paint it exactly as it appears." Goodrich, *Homer*, p. 220. But while this may have been true for certain details of a work, it was not true of any of his works as a whole, either in color or any other matter.

Pl. 3
View of Santiago de Cuba, 1885
West Point Museum

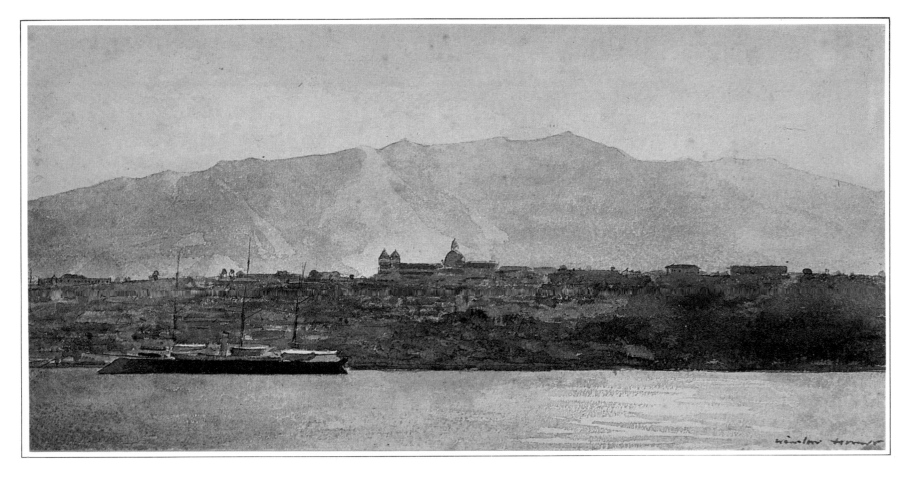

A Chronology of Homer's Travels In the 1880s

1880 Late winter in New York, part of summer in Gloucester, and visits also to Bergen Point, and Field Point, New Jersey. May also have visited Prout's Neck, Maine.

1881 Sails on March 15 for England, arriving at Liverpool ten days later. Visits London, establishes residence in Cullercoats, near Tynemouth. May have visited the Continent in winter of 1881-1882.

1882 Lives and works in Cullercoats with visits down the coast to Bridlington Quay and Flamborough Head. May have visited London for exhibition of his work at the Royal Academy in London. Sails for America on November 11, arriving November 24. Winter in New York.

1883 Late winter and spring in New York. In summer establishes permanent residence and studio at Prout's Neck. Also visits Atlantic City, New Jersey.

1884 Prout's Neck. Sails with fishing fleet to Grand Banks in summer.

1885 Late winter visits to the Bahamas and Cuba. Visits Gloucester in the spring and Florida in December.

1886 Prout's Neck.

1887 Prout's Neck.

1888 Prout's Neck.

1889 Prout's Neck. Visits North Woods Club in Adirondacks in May and October.

During all of these years Homer frequently visited Boston, New York, and other major cities of the east, as well as the homes of friends and relatives.

compiled by Carol Damico

Catalogue of the Exhibition

Dimensions are given in inches, height preceding width.

WATERCOLORS

1. *Two Girls in a Rowboat*, 1880
 9-9/16 x 13"
 Cooper-Hewitt Museum

2. *Young Woman*, 1880
 9-3/8 x 13-3/8"
 Margaret Woodbury Strong Museum

3. *Sunset Fires*, 1880
 9-3/4 x 13-5/8"
 Westmoreland County Museum of Art

4. *Fisher Girls on the Beach, Tynemouth*, 1881
 13 x 19-3/8"
 Brooklyn Museum

5. *Forebodings*, 1881
 14-1/2 x 21-1/2"
 Hyde Collection

6. *The Incoming Tide*, 1883
 20-7/8 x 29-1/8"
 American Academy and Institute of Arts and Letters

7. *The Northeaster*, 1883
 14 x 19-3/4"
 Brooklyn Museum, bequest of Sidney B. Curtis
 in memory of S.W. Curtis

8. *View of Santiago de Cuba*, 1885
 9-1/2 x 19"
 West Point Museum

9. *View of Street, Santiago de Cuba*, 1885
 9 x 19"
 West Point Museum

10. *At Tampa*, 1885
 14 x 20"
 Canajoharie Library and Art Gallery

11. *Old Drover's Inn, Prout's Neck*, 1887
 11 x 19"
 Berry-Hill Galleries

12. *Woods at Prout's Neck*, 1887
 11 x 20"
 Kennedy Galleries

13. *A Good One, Adirondacks*, 1889
 12-1/4 x 19-1/2"
 Hyde Collection

14. *Jumping Trout*, 1889
 14 x 20"
 Brooklyn Museum

15. *Hudson River — Logging*, 1889
 14 x 21"
 Corcoran Gallery of Art, Museum purchase, 1904

DRAWINGS

16. *Smuggler of Prout's Neck*, 1884
15 x 23"
Everson Museum of Art

17. *Fisherman on Shore*, 1884
15 x 23"
Montclair Art Museum,
Lang Acquisition Fund, 1954

18. *Cuban Hillside*, 1885
22 x 16"
Cooper-Hewitt Museum

ETCHINGS

19. *Young Girl in a Chair*, ca. 1875-79
5-7/8 x 4"
Museum of Fine Arts, Boston

20. *The Life Line*, 1884
12-7/8 x 17-3/4"
Margaret Woodbury Strong Museum

21. *Undertow*, ca. 1886
6-5/8 x 10"
Sterling and Francine Clark Art Institute

22. *Eight Bells*, 1887
24-7/8 x 19-1/2"
Margaret Woodbury Strong Museum

23. *Eight Bells*, 1887 (restrike, 1941)
24-7/8 x 19-1/2"
Metropolitan Museum of Art,
Harris Brisbane Dick Fund, 1941

24. *Perils of the Sea*, 1888
16-1/2 x 22"
Margaret Woodbury Strong Museum

25. *A Voice from the Cliffs*, 1888
30-1/4 x 19-3/8"
Metropolitan Museum of Art,
Gift of Mr. Richard Cole, 1966

26. *Mending the Tears*, 1888
17-3/4 x 23"
Margaret Woodbury Strong Museum

27. *Improve the Present Hour*, 1888 (early state of no. 26)
17-3/4 x 23"
Library of Congress

28. *Saved*, 1889
22-7/8 x 32-3/4"
Margaret Woodbury Strong Museum

29. *Fly Fishing, Saranac Lake*, 1889
(Impression inscribed #8)
17-1/2 x 22-5/8"
Margaret Woodbury Strong Museum

30. James D. Smillie after Homer,
A Voice from the Cliffs, 1886
6-3/4 x 10-3/4"
Library of Congress

Pl. 4
At Tampa, 1885
Canajoharie Library and Art Gallery

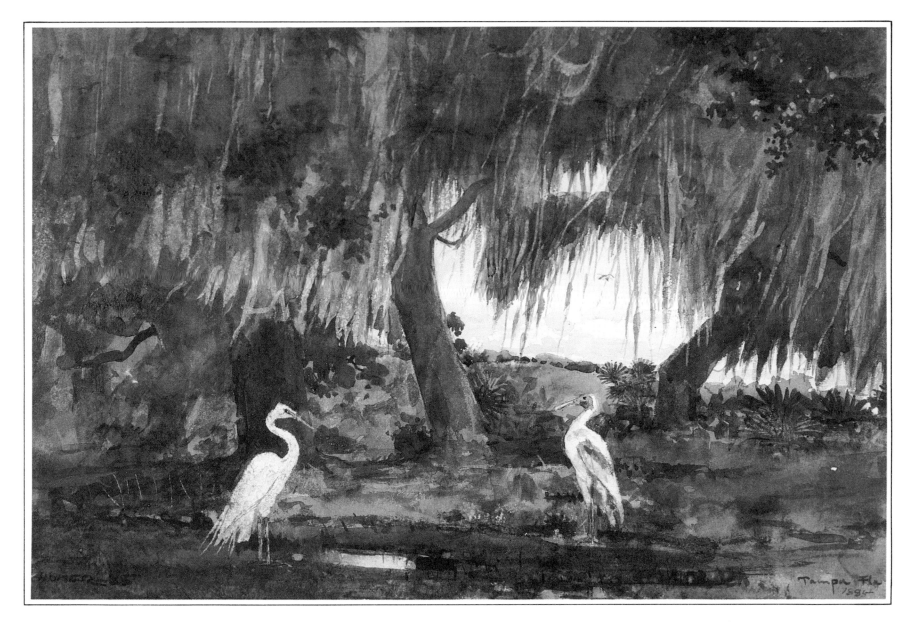

Lenders to the Exhibition

American Academy and Institute of Arts and Letters
New York, New York

Berry-Hill Galleries
New York, New York

The Brooklyn Museum
Brooklyn, New York

Canajoharie Library and Art Gallery
Canajoharie, New York

Sterling and Francine Clark Art Institute
Williamstown, Massachusetts

Cooper-Hewitt Museum
The Smithsonian Institution's National Museum of Design
New York, New York

The Corcoran Gallery of Art
Washington, D.C.

The Hyde Collection
Glens Falls, New York

Kennedy Galleries
New York, New York

Library of Congress
Washington, D.C.

The Metropolitan Museum of Art
New York, New York

Montclair Art Museum
Montclair, New Jersey

Museum of Fine Arts
Boston, Massachusetts

The Margaret Woodbury Strong Museum
Rochester, New York

West Point Museum
United States Military Academy
West Point, New York

The Westmoreland County Museum of Art
Greensburg, Pennsylvania

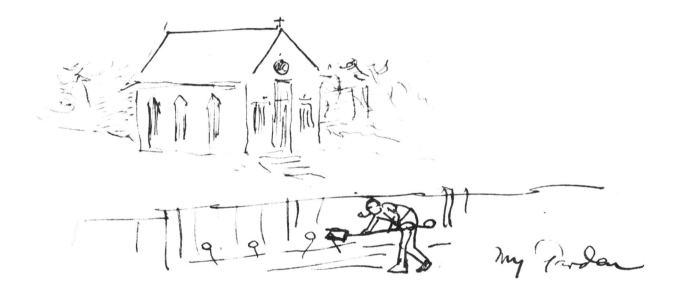

My Garden, sketched by Homer at the close of a letter
(June 19, 1887) to his sister-in-law Martha French Homer,
in which he shows himself at work in his garden at
Prout's Neck across the road from St. James Episcopal Church,
newly built for summer residents of the Neck.
Ink on paper, approximately 3-¼ x 7½",
Bowdoin College Museum of Art.
(Not in exhibition)